chinese BRUSH PAINTING

by Pauline Cherrett

ISBN 1 871517 00 1

Osmiroid Creative Leisure Series

About the Author

Pauline Cherrett, an Architect with the NHS, has been fascinated by anything oriental from childhood. The Eastern concepts of space were absorbed from Ikebana (Japanese Flower Arranging), in which she still has an active interest. Pauline was introduced to Chinese Brush Painting by Jean Long and in the eight years since, has studied with several different teachers, including the three artists whose work appears in this book. After obtaining the Stage 1 Adult Education Certificate in Chinese Brush Painting, she started teaching in Hampshire and other parts of the country. When completing the Certificate of Art and Design at Winchester College of Art, her weaving was based largely on Chinese Brush Painting influences. She has presented several papers and exhibited at Conferences as a member of the Association of Chinese Brush Painters (the final Conference was held in November 1987). She is a founder member and the Secretary of the Chinese Brush Painters Society, and has promoted the art of Chinese Brush Painting with demonstrations/talks for shows and clubs.

The Osmiroid Chinese Brush Painting Kit provides everything you need to start creating exciting chinese brush paintings. As your interest and skill in the art of chinese brush painting grows, you may wish to purchase other materials to develop some of the further ideas outlined in this book as well as your own particular interests.

CONTENTS

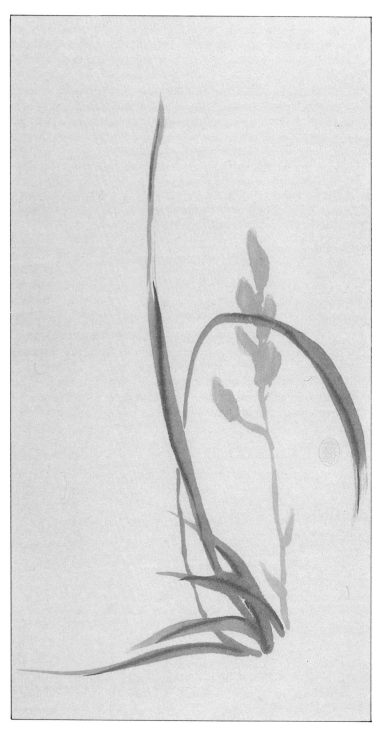

INTRODUCTION

Chinese Brush Painting (sometimes called Chinese Traditional or National Painting), involves the technique of using the brush to express the form and behaviour of an object or a complete scene. By simple strokes, a flower has shape and can be seen to be growing.

It is said that a Chinese-style painting is not complete without calligraphy and a chop or seal (see Equipment Chapter). However, Chinese Calligraphy is an art form in its own right and a single character is often painted and displayed. In this book you will be introduced to the basic concepts of Chinese Brush Painting, with examples for you to try yourself.

Historical Notes

Brush strokes on Chinese pottery date back to 4000 BC. Ever since then the Chinese have used the brush very much in their own way, influencing other Eastern nations over the years. Paper was in existence in 105 AD (and maybe before that time). The oldest silk painting dates back to 400 BC.

Throughout the various dynasties painting has played an important part, especially in court life. During the Han Dynasty (206 BC-220 AD), officials were appointed to be Custodians of Paper, Brush and Ink, and limits were set on the amount of ink to be used each month!

Paintings were mainly undertaken by scholarly gentlemen, sometimes at court, but also while staying at a country retreat. The paintings were not carried out with the subject or scene in front of the painter; it was the impression gained from viewing such things and the feelings evoked, that were later transferred to paper in the Chinese manner.

Traditional techniques have been handed down from master to student over hundreds of years, and it is only more recently that Chinese artists have become fascinated with modern art, following Western concepts in many cases.

How To Learn

The Chinese style of learning is to copy "the Masters", either your teacher or the works of one of the many painters from the past and present. The Chinese feel that you will always put something of yourself into each painting. You are then painting "in the style of", and you should state this.

The aim should be to eventually produce your own original work.

This book does not set out to go into everything in great technical detail, with all the involved Chinese terminology; it concentrates on introducing the reader to the various techniques and provides some exercises for you to try. It is hoped that after painting in the Chinese way you will wish to progress to further techniques in this fascinating art form.

EQUIPMENT

The four essential items for Chinese Brush Painting are called the Four Treasures – ink stick, ink stone, brush and paper.

Ink

Black has been used for decoration in China since 2500 BC. Many paintings use "shades of black", and it is possible to achieve seven shades (including black itself).

Ink is used in either stick form or ready-to-use liquid form. The latter is generally used for practice work. The importance and liveliness of freshly ground ink is preferable and also enables the artist to think of "noble thoughts" and therefore to relax, whilst preparing the ink.

The ink stick is made from pine or oil soot mixed with resin and gum. When used it is ground on the surface of an ink stone until a suitable consistency is reached. A good ink stick is light in weight, with a sheen rather than a shine, and must be capable of producing different shades.

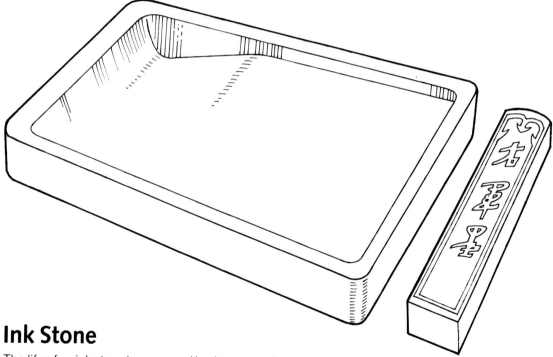

Ink Stone

The life of an ink stone is measured by the generation, and ground ink by the month. Modern ink stones are carved from slate or stone and often contain two parts; a recess to hold water and a flat surface for grinding the ink. The stone must be impermeable and capable of producing fine ink.

An ink stick should *NEVER* be left in contact with a wet ink stone. The gum will ensure that a near-permanent joint will be made, and it will be the stone which will suffer damage. As with most equipment, treat it with respect, and you will benefit from pleasure in use and lasting quality.

The size of the stone will vary with taste and pocket; those who repeatedly paint to a large scale will require a larger stone. Most of the stones sold in the West will suit the average Chinese Brush painter.

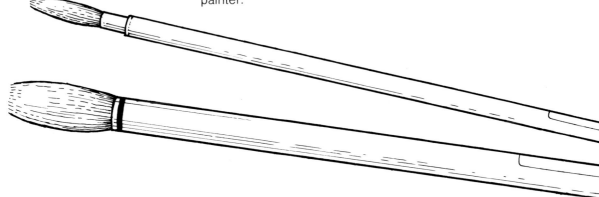

Brush

The brush is said to show the substance and behaviour of things, and it is of prime importance in the Art. Chinese brushes are very special and have no substitutes. The art of making brushes was exported to Japan from China in the T'ang Dynasty but the development in both countries since then has been different.

Varying materials are used including fibres from sheep, goat, rabbit, barbs of a feather, wolf, badger and pig bristle. Other brushes are made of two types of fibre. Brushes may be soft and flexible, or hard and inflexible. All brushes should be resilient.

Brushes generally consist of layers of long and short hair, the space in between acting as the ink reservoir. A good brush will hold more ink than a poor one. Some artists use only one brush for their work, but this does rather depend on the scale of paintings, and the brush quality.

Paper

Paper has been in existence from around 100 AD. The original paper was made from many different materials including pulp, old fishing nets and bark.

Modern papers are often machine made, and several practice papers are from Japan. It is classed in degrees of weight and

amount of size used. The paper is very absorbent and the amount of size in it will dictate the quantity of ink which is absorbed by the paper.

For freestyle work unsized paper will be required; for meticulous figure paintings a heavily sized paper is necessary. The smooth side of the paper should always be used to enable the brush to slide over the surface. Most papers come in roll or sheet form, and in varying widths.

Typical example of practice paper.

Other Essentials

Besides the ink stick, ink stone, brush and paper, you will require an absorbent backing – start with newspaper (beware the ballpoint pen on the crossword puzzle!) and maybe find some felt or well-washed blanket which is then kept rolled rather than folded. Two waterpots and a palette are important – the latter can be a plain white or cream plate.

The other essential items not yet mentioned are colours of some description. The ideal are Chinese colours which are a pure source of colour. These flakes of pigment are dissolved in warm water, then used and mixed as any other watercolours. Japanese watercolours can also be used. The Western types in tubes or pans have additives in them which prevent the colour soaking into the paper so readily. This is really only a problem if paintings are mounted in the Chinese manner when the colours will be enhanced and may run. Any watercolours that you have at present can be used to start with. Colours made from natural ingredients are either mineral or vegetable based. The former are opaque and the latter are transparent. These properties can be exploited. All colours can be mixed with each other and with the black ink.

Examples of a "Mother and Child" seal owned by the Author (rather like a Russian Doll with 25 seals). Seal script.

Five kinds of colours.

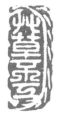

Hastily and carelessly.

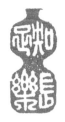

Satisfaction means happiness.

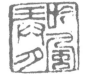

Chanting with the wind, playing with the moon.

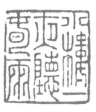

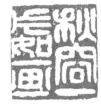

Listening to the spring rain in the night on a low storied pavilion.

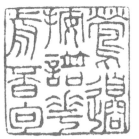

When approaching an oriole cover your musical scores, in front of the flowers don't read poems.

The autumn scenery is like a painting.

Accessories

As with many hobbies, some basic equipment is required to carry out the work, followed by other less essential, yet often desirable, items. Paperweights, seals (a method of "signing" your work), brushrests, and brushpots all come into this category. Often a domestic alternative is to be found but it is nice to accumulate some things that you enjoy using.

Coins can be used for holding the paper down, or other similar shapes – flat metal bars are also useful. The seals can be purchased but can also be carved, either in stone or rubber. The former is preferable but the latter easier for most people to carve if you wish to make your own. These can contain a name, poetical saying, a design or symbol which has a connection with the painting. These seals are pressed into a pot or tin of cinnebar paste, a scarlet red colour, and are then impressed onto your painting. The paste contains mercuric oxide, ground silk and oils

which are absorbed by the paper, and care should be taken that it is not spread further than required as it is rather permanent! Care should also be taken as the paste is poisonous. When used on a monochrome painting then one is said to be ''adding the eye to the dragon''.

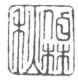

Some more seals owned or made by the Author. Mainly in seal script.

Author's name – two differing styles of script.

Author's name – carved from a rubber.

Long life

Congratulations/Best wishes

Happiness

Happiness – carved in intaglio style from a rubber.

Double happiness

Good luck – carved from a rubber.

Double happiness – carved from a rubber.

FIRST STEPS

It is important to find a quiet corner in which to work with a surface large enough for your painting and equipment and either space or a stand to hold what you are following. Obviously, as with any art or craft work you will need good light. It is also important to have a chair which is sufficiently high to allow free arm movement over the table surface, or you may prefer to stand. Try both ways to find your preference.

You will need two water pots – one for "clean colours" (flowers with no black ink added) and the other for colours which have had ink included. (If cups of tea, etc. are on the table it is likely that you will put your brush into the wrong container at some stage!). At this point you should prepare your brush. After purchase it will have a very hard pointed appearance. It should be stood in cold or lukewarm water (never hot, as this will dissolve the glue) and after several minutes of soaking, should be gently pressed against the sides of the waterpot to remove the starch which has been used to protect it during transit. Never return the cover onto the brush as this will ruin it.

Having assembled your ink stone, ink stick, paper, brush and water pots, you are ready to start. Put a small quantity of water onto the ink stone with a spoon or dropper – two teaspoonfuls will take about 400 revolutions to grind the ink properly, so about a half teaspoonful should be used to start with!

Pick up your ink stick, and using a circular motion start to grind the ink on the inkstone, (a clockwise direction will feel natural to most people). The pressure needs to be firm but not forceful. When dry patches begin to appear in the ink then it is time to test for blackness. While you are preparing your ink try to relax and quietly think about what you are going to paint. This meditative process is very important in Chinese Brush Painting.

To start, unwind some of the paper, and dipping your brush into the clean water, "paint" a line down the paper and it will then easily tear off where required. Hold the paper down with coins or other flat weights. Having prepared the ink, transfer some of that ink from the inkstone onto your palette, dilute it with varying amounts of water and test on the paper to see how many shades you can achieve. Try also using the brush very wet and almost dry, then you will start to realize some of the effects which can be achieved. The technique is to know when and how to control stroke colour, pressure, wetness and density.

The brush is held in a similar fashion to chopsticks, the handle being supported by the third and fourth fingers, first and second fingers on top of the handle and the thumb balancing the other side. The hand should be shaped as though holding an egg as well as the brush. The wrist should remain stiff while the fingers and arm do the movement. The position of the hand on the brush will

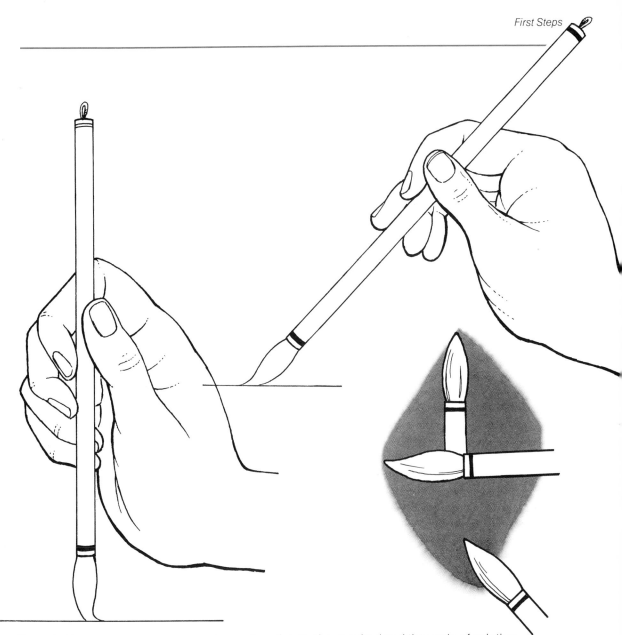

How to hold the brush for different strokes. You should make sure that you hold the brush correctly, as it will help you in your brushwork.

depend on the stroke required and the scale of painting. Experiment and find the right level, which will be higher than you are used to at present. The more freestyle work will require the hand to be at a higher level. Whether the brush is held vertically or sloping is also important. The more powerful the stroke, then the more upright the brush should be; i.e. vertical for stems, slanting and at various angles for petals. When painting it is essential to get free movement so that the strokes are fluid, so do not be tempted to rest your wrist or hand on the table. If work is very small and detailed it may be necessary to rest the wrist only.

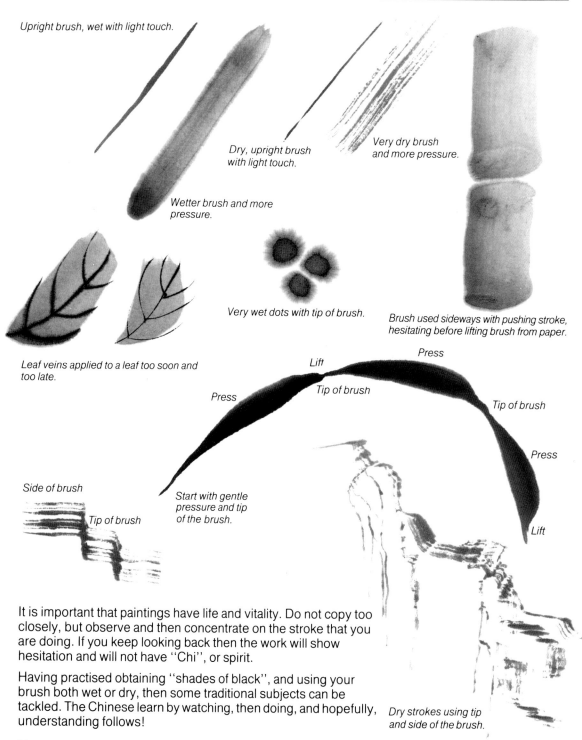

Upright brush, wet with light touch.

Dry, upright brush with light touch.

Very dry brush and more pressure.

Wetter brush and more pressure.

Very wet dots with tip of brush.

Brush used sideways with pushing stroke, hesitating before lifting brush from paper.

Leaf veins applied to a leaf too soon and too late.

Press *Lift* *Press*

Tip of brush

Tip of brush

Press

Side of brush

Tip of brush

Start with gentle pressure and tip of the brush.

Lift

It is important that paintings have life and vitality. Do not copy too closely, but observe and then concentrate on the stroke that you are doing. If you keep looking back then the work will show hesitation and will not have "Chi", or spirit.

Having practised obtaining "shades of black", and using your brush both wet or dry, then some traditional subjects can be tackled. The Chinese learn by watching, then doing, and hopefully, understanding follows!

Dry strokes using tip and side of the brush.

SOLID STROKES

In order to appreciate some of the freedom of the brush, it is best to get accustomed to the solid strokes. This makes maximum use of the width and length of the brush and also allows the full potential of wet and dry techniques to be realised.

Load the brush carefully making sure that you wipe off excess ink on the side of your palette obtaining a pointed end to the brush. Then, holding the brush correctly, place the tip of the brush onto the paper, and while moving the brush gradually increase then decrease the pressure on the paper, bringing the point off last of all. You should have a petal or leaf shape on the paper. Practise this stroke, working round in a rough circle to get used to the different angles required to obtain a flower shape. Of course, if you study any flower, you will see that when viewed from varying angles the petal shapes and proportions will change, and good observation of this will help you paint flowers which look natural.

Two and three colour brush loading.

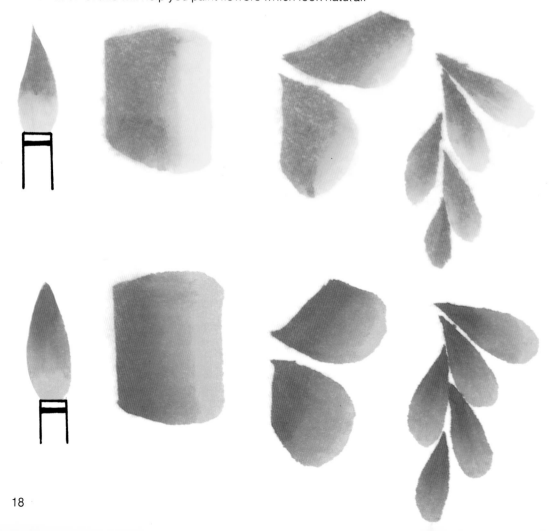

While you are practising this stroke try some two and three colour brush loading. This is very attractive when used selectively, but beware of using it all the time as the effectiveness can then be lost. Dip the whole of the brush into a colour or shade of ink, wipe off the tip, and put the end of the brush into another colour or shade.

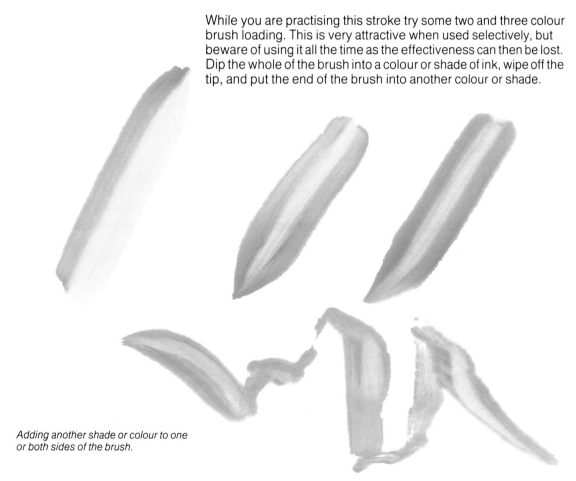

Adding another shade or colour to one or both sides of the brush.

Experiment with pulling the brush sideways and you will obtain your shading or change of colour in one stroke. This can be especially useful for giving bamboo stems roundness. When using three colours, dip the whole brush in and wipe off two-thirds, then dip in that two-thirds and wipe off a third, dip the point in and do your stroke. The effect will gradually decrease with further strokes as the colours or shades of ink begin to blend. This can be used to advantage.

Whilst you are practising these strokes, try to deliberately make the shapes fatter, thinner, longer or shorter, so that you become familiar with the brush and learn how to develop control of it as well. You will see from the illustrations that the brush can be pushed or pulled, either vertically or sideways; the tip or the whole brush can come into contact with the paper. Dry brush strokes can be used to give rough texture to a branch or to rocks, whilst a very wet brush can give an appearance of fur to an animal.

19

Follow through some of the exercises, making sure that the brush is loaded carefully and thoroughly each time. Care with brush loading will become a habit which should stand you in good stead for successful painting. The practice pieces are traditional subjects and ones which most people associate with Chinese Brush Painting.

The orchid can be marsh, grass or Fukien variety. The first two were painted by the literati painters, the latter is usually painted to express summer. There is a lot of symbolism in Chinese painting, much of it with Taoist, Confucian or Buddhist links. Landscape principles are especially linked with ideals of paradise, etc. Orchids are symbolic of modesty and purity.

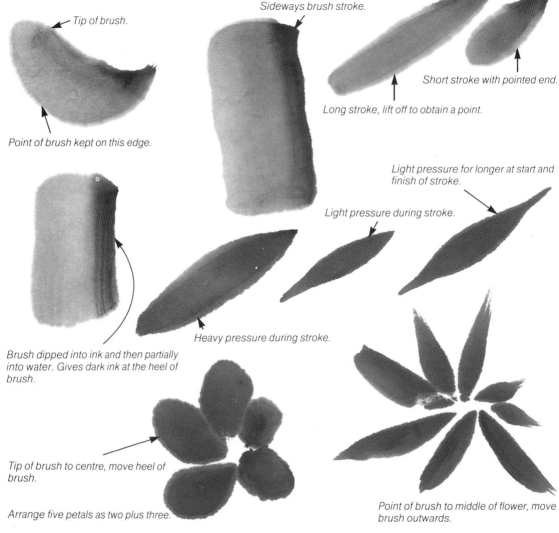

Tip of brush.

Point of brush kept on this edge.

Sideways brush stroke.

Short stroke with pointed end.

Long stroke, lift off to obtain a point.

Light pressure for longer at start and finish of stroke.

Light pressure during stroke.

Heavy pressure during stroke.

Brush dipped into ink and then partially into water. Gives dark ink at the heel of brush.

Tip of brush to centre, move heel of brush.

Arrange five petals as two plus three.

Point of brush to middle of flower, move brush outwards.

Orchid. Start from the centre of the flower, and starting with the tip of the brush form each petal by pressing down and sideways, before lifting the brush at the end of the petal. Leaving a small space at the centre, position each petal so that you achieve a flower shape. Do not paint the flowers all looking the same way.

Orchid flowers grow on alternate sides of the stem. After the petals, put in the centres and stems. The leaves should be painted in a lively fashion. Make them twist and turn by lifting the brush and then pressing down again, while making the stroke.

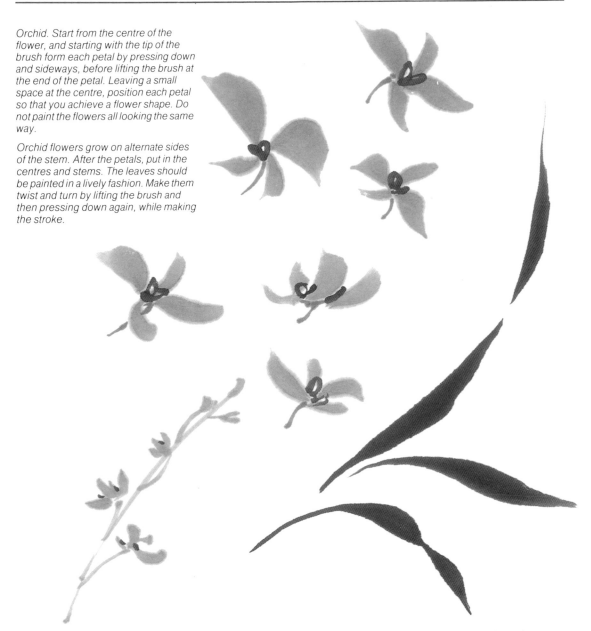

Orchids are fragile flowers which are protected by robust leaves. The stems are lively and playful. The number of flowers per stem differs with the variety, between one and seven. The aim should be to convey the idea without painting every leaf. Although the flowers are not painted to exact botanical detail, unless shades of black are used, the colours chosen should be from the plant's ''natural'' palette.

21

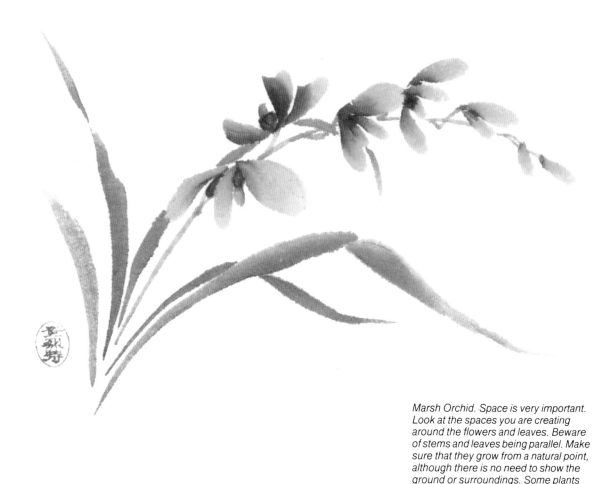

Marsh Orchid. Space is very important. Look at the spaces you are creating around the flowers and leaves. Beware of stems and leaves being parallel. Make sure that they grow from a natural point, although there is no need to show the ground or surroundings. Some plants are painted with the roots showing.

Chrysanthemums are one of the ''Four Gentlemen'' – from Confucian ideals of behaviour – the others being plum, bamboo and orchid. They are signs of autumn, joviality, ease, scholarship and retirement. The gift of a painting with a suitable symbolic meaning therefore becomes rather special.

Defiant of the frost and autumn, chrysanthemums are of proud disposition. The buds are light and so stand tall and straight, the flowers have more weight and therefore the stem bends a little. Characteristics like this will assist in a satisfying painting. The flowers can be in a tight ball or in a daisy-like form; they grow in a

The Chrysanthemum requires some buds and flowers together with its leaves. The number of leaves in this composition has been reduced to avoid a cluttered appearance. Order of painting – flowers, leaves and then stems.

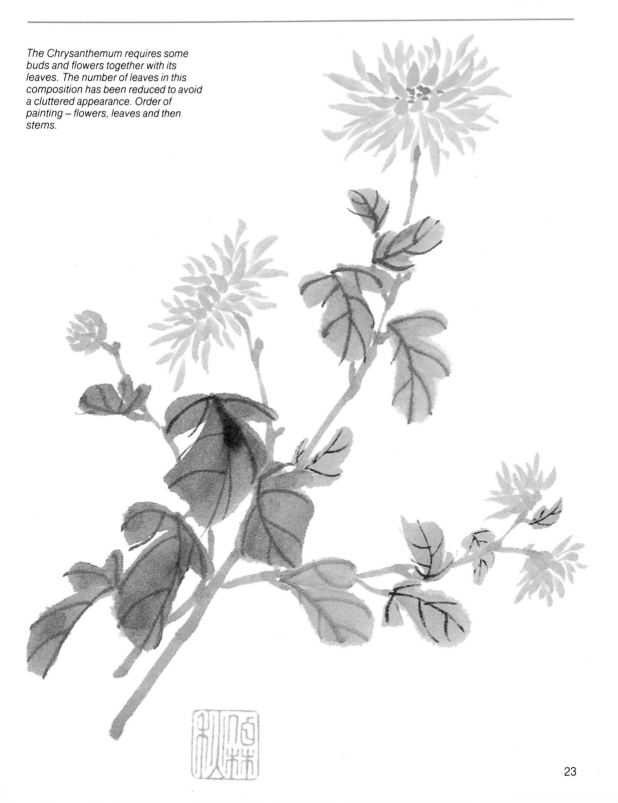

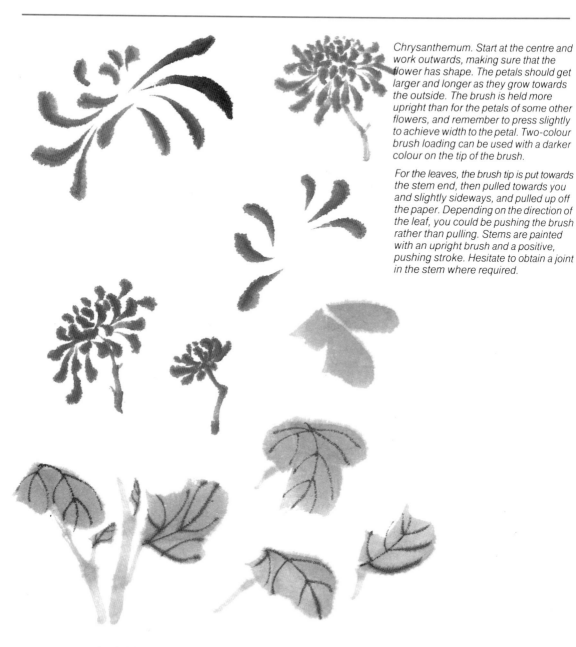

Chrysanthemum. Start at the centre and work outwards, making sure that the flower has shape. The petals should get larger and longer as they grow towards the outside. The brush is held more upright than for the petals of some other flowers, and remember to press slightly to achieve width to the petal. Two-colour brush loading can be used with a darker colour on the tip of the brush.

For the leaves, the brush tip is put towards the stem end, then pulled towards you and slightly sideways, and pulled up off the paper. Depending on the direction of the leaf, you could be pushing the brush rather than pulling. Stems are painted with an upright brush and a positive, pushing stroke. Hesitate to obtain a joint in the stem where required.

spray or as a single bloom. The petals may be curved or recurved, with pointed or rounded tips (achieved by the way that you lift the brush from the paper). Consider how the leaves twist and bend. They can be done as one, two or three strokes, the vein being put in afterwards (before the leaf is totally dry, but not while it is so wet that the vein stroke runs immediately). Do the centre stroke first. Show the leaves at differing levels and angles.

To practise a different leaf shape, lotus flowers have been included. The flowers, rising from muddy water again indicate purity, also summer, fruitfulness and spiritual grace. They are pink, white or yellow; two metres high with one metre diameter leaves. Most parts of this plant are used for food or medicine. In a coloured composition, the leaves are often painted in "shades of black" rather than a colour. This accentuates the purity of the flower.

The Lotus leaves require a lot more ink, some of it diluted to different shades. They should be painted in bold strokes adjacent to each other so that the ink flows from one stroke to the next and so creates the correct shape rather than remaining as individual strokes. Work from the centre of the leaf out to the outer edge.

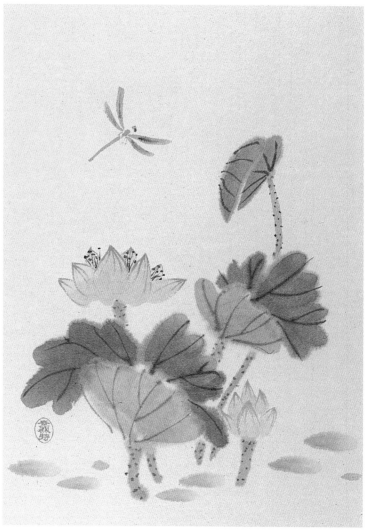

The Lotus composition should include flowers and leaves in differing stages. The water they are growing in may be shown if you wish. Otherwise it is implied by the type of plant portrayed. Beware of parallel stems, except in short lengths – once a stem is long, it will bend and twist differently to its neighbour.

As you practise these flower paintings, it would be a good idea to include the appropriate calligraphy for each subject to get into the habit of including it in your work.

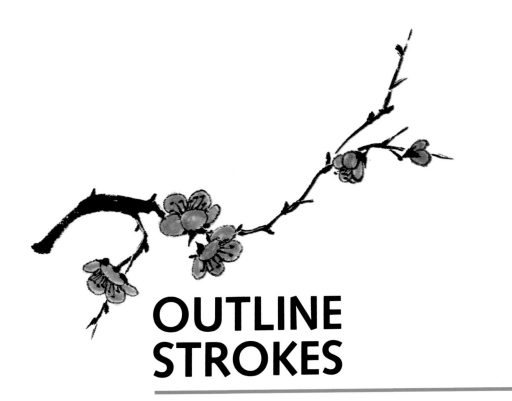

OUTLINE
STROKES

While most Chinese Brush Painting is of a freestyle nature, work done in outline has been traditional since ancient times, especially for subjects such as orchids. Outline and solid strokes can be mixed together with maybe the flowers in the former and the leaves in the latter.

A common use of the outline technique is for depicting the plum blossom. This flower contains mystery and a certain beauty in the barrenness of winter; it then shows the promise of spring. Paintings of plum do not usually contain fruit or leaves, the new shoots are bold and young, the older, wiser branches are withered. Think of the weather and prevailing conditions – these affect the distribution of blossom. You would not expect to find masses of flowers on an old tree. The plum is symbolic of winter, long life, strength, hardiness and triumph. It is usually painted in pink, white or cream, with five petals. The branch is shown in such a way as to emphasize the rough texture and gnarled growth.

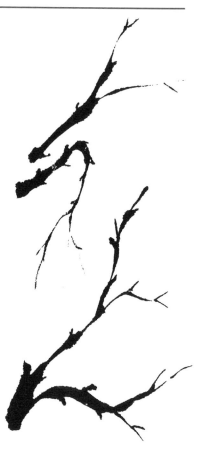

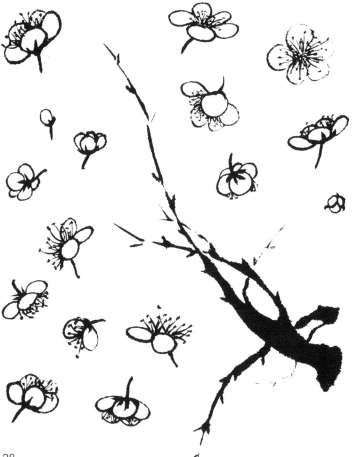

Different Plum Blossom flowers. Some will be new, and others old with petals missing. Start by painting the outline of each petal in a single stroke with a fine brush. It is easier if you start with the petals in the front. Next add the sepals with two or three strokes depending on the attitude of the flower. The brush should go from stem to tip. Then add the stem. The stamens are added last. Do short flick strokes from base to tip making sure that the brush lifts off the paper to give a fine end. Add the dots in moderation.

The branches should be textured and powerful. Hold the brush upright and paint with confidence, hesitating at the changes of direction or branching points. As you hesitate the ink will soak into the paper more to give a "knuckle" joint. Texture is achieved by a drier brush and "flying white" – spaces between the ink.

Traditionally the Plum Blossom is painted with the branches first, leaving spaces for the blossom, followed by the flowers. Make sure that your blossoms face in different directions – "it is rude to stare" is a convenient way to remind yourself of this.

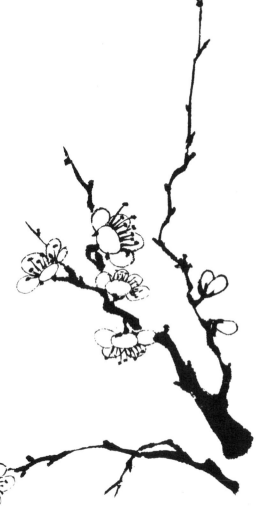

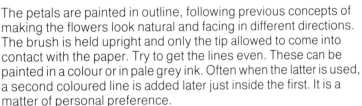

The petals are painted in outline, following previous concepts of making the flowers look natural and facing in different directions. The brush is held upright and only the tip allowed to come into contact with the paper. Try to get the lines even. These can be painted in a colour or in pale grey ink. Often when the latter is used, a second coloured line is added later just inside the first. It is a matter of personal preference.

The outline petals can be painted with a smaller brush if you wish, but it is good practice to learn how to control a larger brush for fine lines. It is best to have a slightly drier brush for thinner strokes. Brushes do improve as you become accustomed to their use and "wear them in" to your own style.

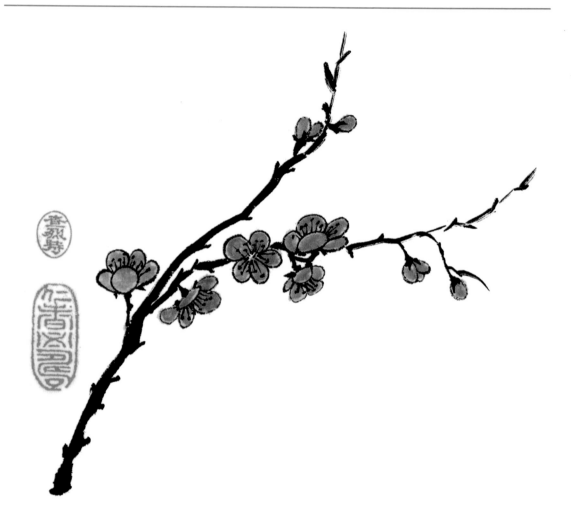

The branches will require more ink or colour, and a larger brush if the fine one has been used for the petals. The brush should be drier than before, held vertically, and be pushed away from you towards the top of the paper. Hesitate in your stroke without removing the brush from the paper and you will find that a gnarled effect will be the result, especially if you change the direction on resuming the stroke again.

From the first exercises you should have noticed that there is far more space in and around the paintings than in Western art. This space is very important. Often, when paintings are illustrated in books, the whole picture is not shown and therefore the spacial concepts are distorted. The compositions for Chinese Brush

After painting the flowers in the outline style, a second coloured outline may be added just inside the first, or a colour wash applied in each petal shape.

Painting need a lot of thought, and careful study of books and other sources is advisable. It is often the simplicity which appeals rather than the subject matter.

If at any time your brush misses the paper, do not be tempted to go back over your line – your brush might be absent but the spirit of the painting should still be present! In the same way do not attempt to repeat one stroke over another – it will show up and your work will lose some of its spontaneity. You should remember also that the ink is absorbed by the paper and any extra that you put over the top will stand less chance of being absorbed, and therefore may cause problems when mounting the work.

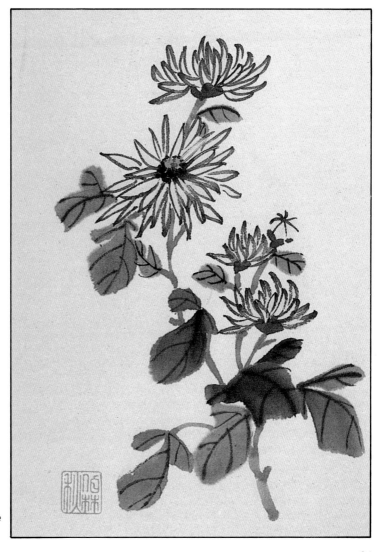

Chrysanthemum in outline style. The leaves here are painted in the "boneless" technique as before. The same rules of shape, space and attitude apply as for the solid style.

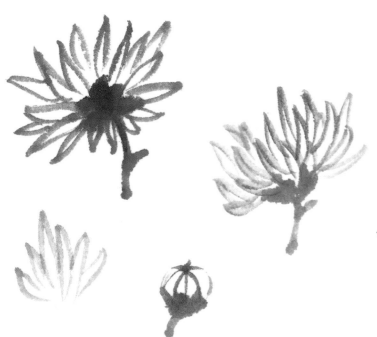

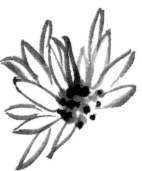

The chrysanthemum flowers should be painted from several angles. Paint the petals in dark or light grey in two strokes from tip to centre. Any application of colour is undertaken afterwards. When painting a flower "full-face" start with the centre and put in the petals around the middle. Then add the next row and any more as necessary. The flowers should not be painted in a regular shape or they will look false.

Another flower which is often painted in outline form is the chrysanthemum. The petals can either be reflex or incurving. The outlined petals can be filled in with colour if desired, although it is better if this is not done too exactly. The leaves can be painted in outline or solid. Very often work looks more lively with solid leaves.

The orchid and lotus from the previous chapter can also be painted in outline style. Again the leaves are often in the more freestyle, solid stroke.

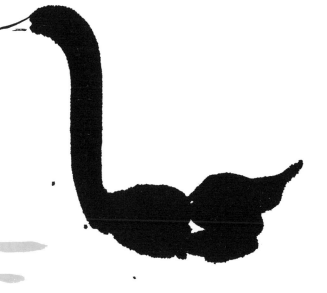

OTHER SUBJECTS

There are many subjects which can be portrayed in the Chinese manner. Some of them are traditional, others are more to the taste and knowledge of the Western world. Chinese Brush Painting has influenced many artists and as you become more familiar with the technique you will recognise the signs.

Birds and fish are very popular and it is in this field that most of the humour occurs. The Chinese enjoy their painting and often there are amusing undertones, which we do not always appreciate.

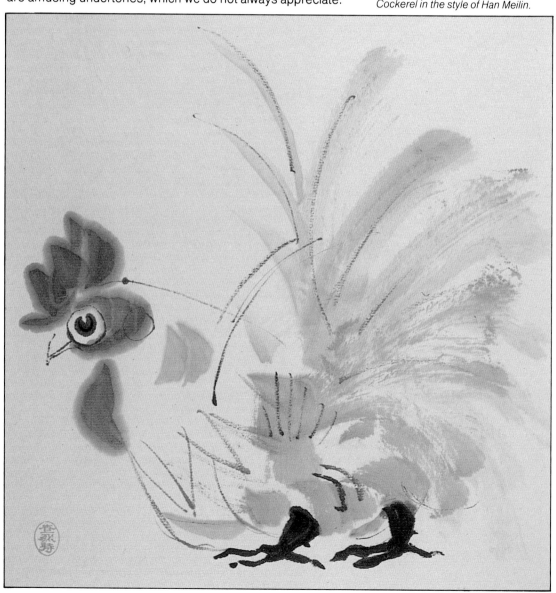

Cockerel in the style of Han Meilin.

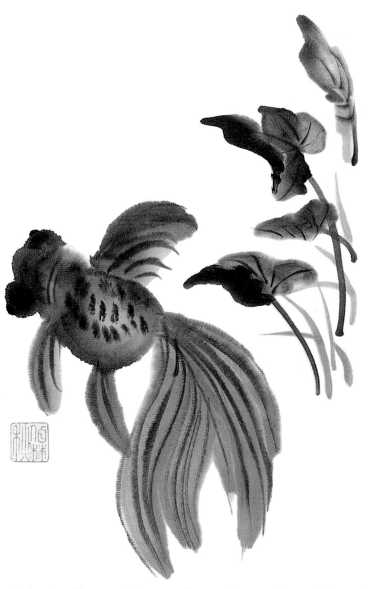

Fish and Waterplants. The water is implied by the subject matter.

Animal and figure paintings are frequently seen; if an artist is good at one then usually both are done well. The list of other subjects is almost endless if one includes butterflies and the insect world.

With subjects like fish it is not always necessary to show the background or to prove that there is water surrounding that fish. The behaviour and attitude of the fish should be such that its environment is obvious. The same is true of plants and flowers; it is not necessary to show soil around the stems, just indicate a natural growth point.

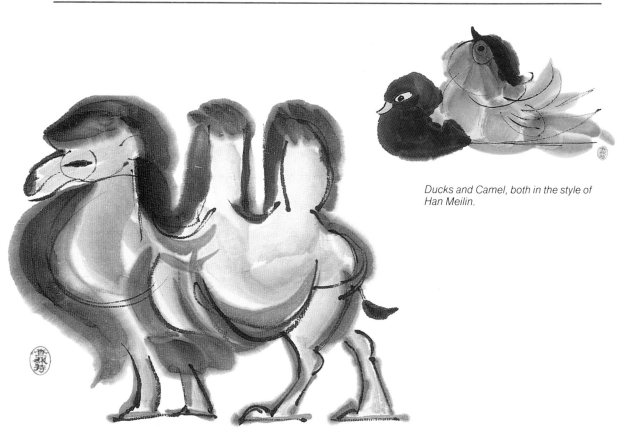

Ducks and Camel, both in the style of Han Meilin.

Prawns are a favourite subject and can be carried out with vigour and spontaneity. Be sure that you observe where the point of the brush is and the direction of the stroke. It is advisable to change to a fine brush for the feelers as these really do need to be thin lines, otherwise the effect will be lost.

When painting birds and fish it is best to start with the eye, then the mouth, followed by the head and the rest of the body. Make sure that your bird is sitting securely on the branch and not just about to fall off!

Some of the interpretations of animals and birds are rather like caricatures and certain artists have developed a style all their own when dealing with these subjects. Pick out the essential things which differentiate one from another and you will find that these will help make your painting believable.

By using a wet brush and leaving that brush on the paper for a few seconds, you can obtain a fuzzy outline which will look like fur. Watch what is happening, but remember that there will still be some ink to soak in after the brush has left the paper. When a wet

Prawns. There are three main strokes to the head (two in one direction and one the opposite way). Do a stroke at each side of the front of the head. Four or five curving, sideways strokes are used for the body (point of brush to the head), and three for the tail (point of brush to the body). The claws are painted from the tip of the claws to the body, hesitating at the joints. Using a fine brush and dark ink, paint the feelers without any hesitation! If the brush leaves the paper before you have finished the stroke, go on to the next one and do not be tempted to go back to the interrupted stroke.

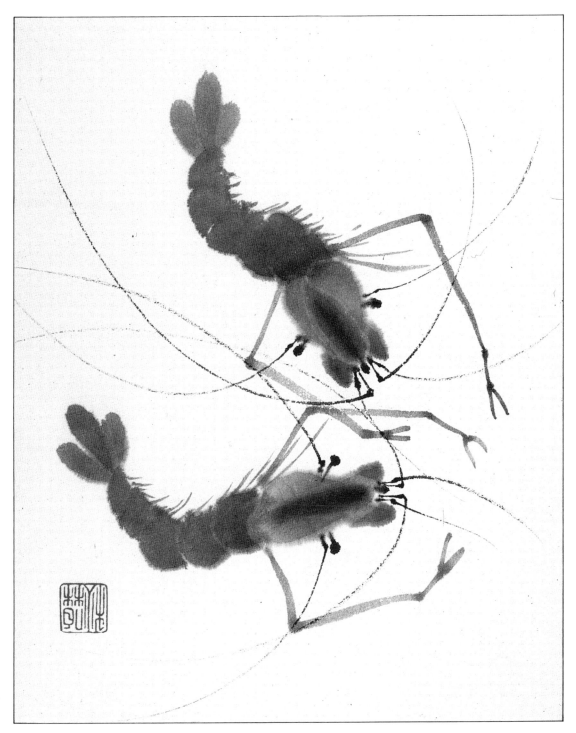

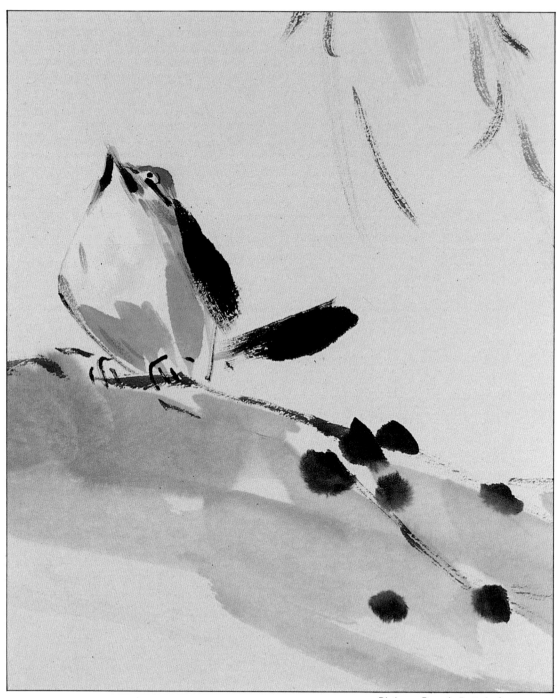

*Bird on a Branch. Part of a larger
painting by Professor Joseph Lo.*

brush is used and several applications of the brush are made close to each other, you will notice that the water soaks into the paper further than the ink, leaving a line round the strokes which will look like feathers. This can be used to an advantage on the breast of an eagle for example, but some batches of paper are better than others for this technique.

Another field of interest is the depiction of fruit and vegetables. The former is often shown in a basket or in its natural surroundings. Frequently just a branch of lychees or rambutans is portrayed. Any texture to the fruit helps to ''set the scene''. Once again it is showing what the subject is without painting every leaf or fruit. Slices of melon etc. can be painted standing on a plate – but it is preferable to show Chinese style decoration if any is used. With vegetables, Chinese leaves are very popular.

Basket of Fruit. Ensure that the fruit is rounded and has a believable colour. Some leaves included in the composition will help.

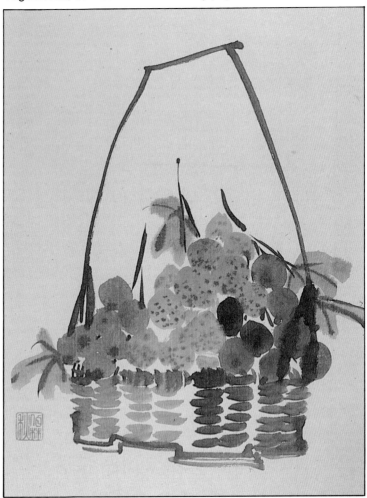

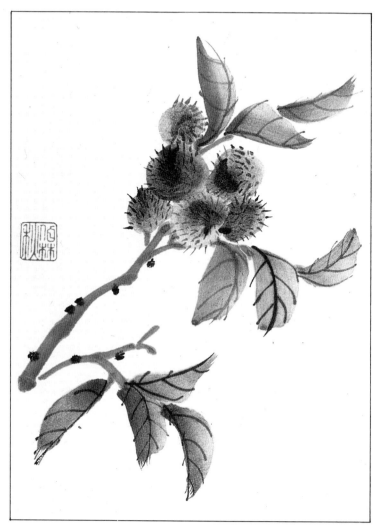

Rambutans. These are similar to lychees — a crisp outer shell which is hairy, with a moist white fruit inside containing a stone. Use a circular motion with a sloping brush and moderate pressure, make use of the darker marks left by the start and finish of the stroke to help give form and angle to the fruit. As with flowers, do not have them all facing one way. The hairs should be put on with a fine brush in a flick stroke from the fruit to the point of the hair. The leaves are painted from stem to tip and followed (before totally dry) by the veins. The stems should be strong and stiff (upright brush).

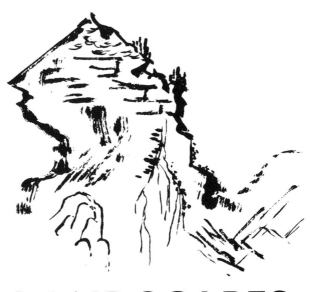

LANDSCAPES

Chinese landscapes have been described as timeless mountains and endless waterfalls. The Chinese word for landscape means mountain water.

The Chinese use differing levels rather than scientific perspective; the sense of space being more important than convention. The idea is to show the immensity of nature and the smallness of man by comparison. During the Ming Dynasty, there was a split into two schools – the Northern (outward view), and the Southern (inward view). This had an enormous effect on the way styles of landscape painting developed.

Looking up to a mountain is described as high perspective, looking from mountains in the foreground to mountains in the background is known as deep perspective, and across a flat landscape is called a level perspective.

It is said that to paint landscapes, you must first be able to paint trees. They have a guest/host relationship (one overlooking the other). There are four main branches. Look carefully at groupings of trees. There are many different forms of trunk and foliage. Trees can be painted in outline or in solid form. Some artists start at the top and work downwards, others believe in working in the direction of growth. You may find the latter easier to start with. A tree is darker at its extremities where the branches and twigs are more in silhouette.

A group of trees. Notice the guest/host relationship. Many modern graphic techniques are based on the brushstrokes used in Chinese Landscape Painting. These trees are painted in Liu Sung-Nien style.

These landscape strokes illustrate just a few of the techniques. There are many more. The foliage and plant strokes are used to illustrate differing trees and shrubs. A smaller brush is often used for detailed foliage.

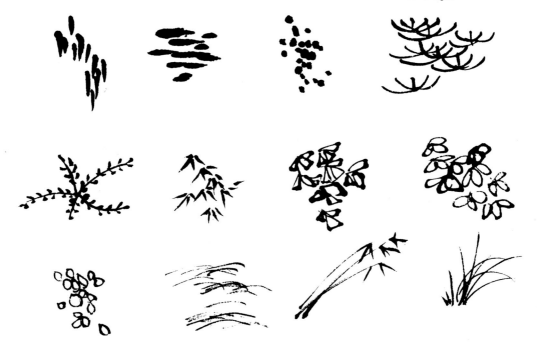

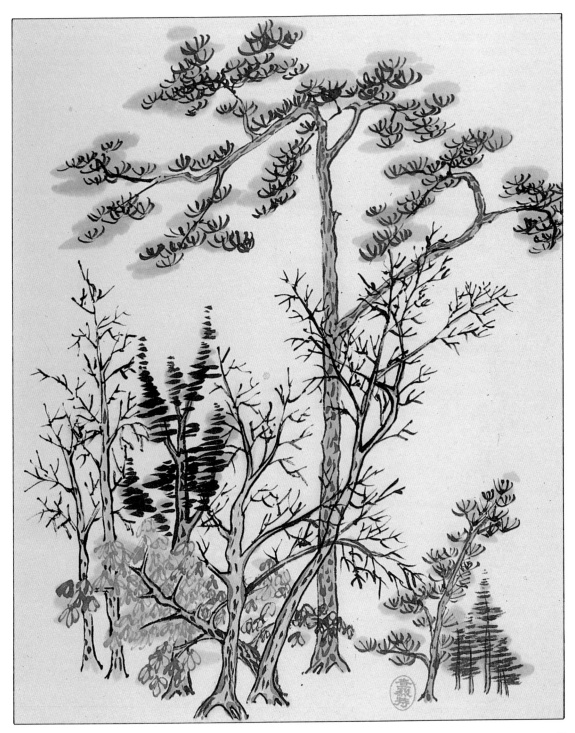

Rocks must have "Chi" or spirit, they should have "three faces" (Taoism), and above all they should look like rocks. Outline the mountains, then use modelling strokes to complete. These strokes have expressive names like hemp fibres, axestroke, ravelled rope, lotus vein, confused cloud and severed band. Do not mix the stroke styles when painting a single rock, or use too many variations within a landscape. Rock formations tend to change gradually across a scene.

Water is a feminine form, being soft amongst the masculinity of rocks and mountains. Yin and Yang, equal and opposite, play a great part in all Chinese culture but are especially important in landscape work. Clouds and mist are fluid forms, and these are often suggested most effectively by blank space on the paper.

The rock strokes are painted with both the tip and side of the brush, and a mixture of wet and dry loading.

People and belongings are often shown small and out of scale – indicative of Taoist ideals. Servants are frequently shown much smaller than the master, and have been mistaken for children. It was a traditional way of showing the order of things.

There is a lot of symbolism used in landscape, the most common being the use of pine trees for longevity, courage and immortality. Sky blue and burnt sienna are traditionally used (with restraint) for rocks and mountains. Look at books and illustrations, and you will see the effect. It is often described as ink and light colour.

Principles of landscape painting are covered in many books, most of them originating from "The Mustard Seed Garden".

A simplified landscape with water. The actual water area is not shown, but merely implied. Misty gaps between mountains give the idea of space and distance.

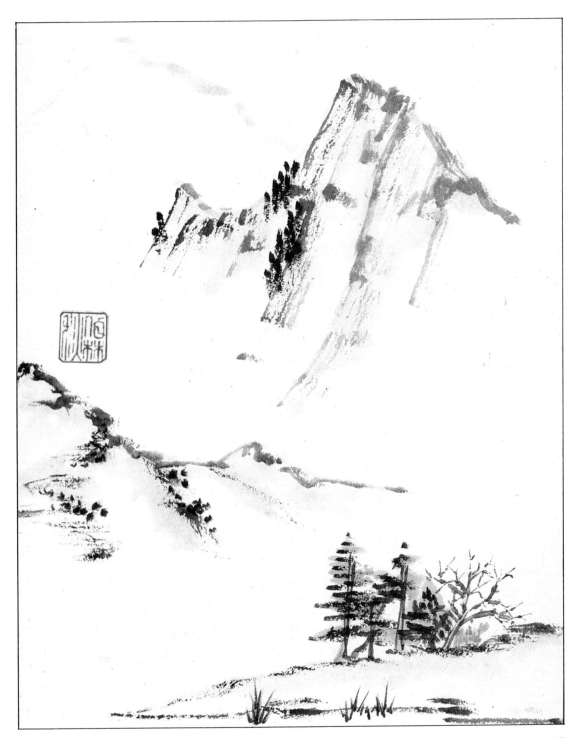

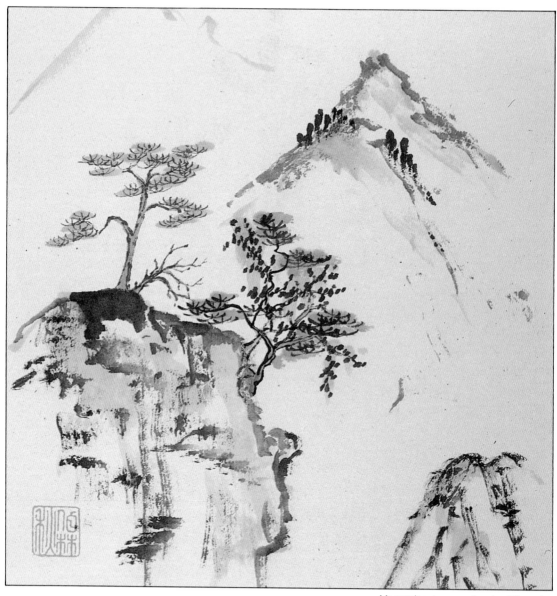

Mountains, trees and rocks. After using ink to get the desired effect, "light colour" is used to add emphasis and liveliness. In a traditional landscape, strong colour should not be used. It is often light shades of blue, sienna and green. The names vary with the origin of the paints, and some styles of landscape require different blues on close and distant mountains for example.

CHINESE
CALLIGRAPHY

Chinese Calligraphy is very much linked with painting. A completed painting contains calligraphy and a chop or seal, (maybe more than one). The dictionary description of calligraphy is beautiful handwriting.

Marks were made on shells or bones and used as oracles for making decisions. These marks were then developed into pictograms and gradually into characters. The first books were made of thin slats of bamboo or bone, laced together. Vertical columns of characters have been used ever since.

Various styles have been developed including seal script (often used on seals), official and regular scripts (formalised characters), running hand (hand writing), and grass style (abstract form).

The inscriptions on existing paintings can be poems, descriptions, dedications or political allusions. They are not necessarily by the artist and may be added years later. They can also be approving or the reverse. It is therefore advisable not to copy blindly!

Development of styles. This is shown in a very basic form. There are many more styles, some with only a fractional difference between them.

Cursive *Regular* *Pictogram*

Mountain

Cursive *Regular* *Pictogram*

Water

In order to get the proportion and stability correct, it is best to practise regularly and to use either folded paper or a ruled template.

The nine fold square will be a guide but the proportions of characters vary depending on whether they consist of more than one component.

Folded or ruled templates help with calligraphy practise. Each character takes up an equal "space". Poorly executed or spaced calligraphy will spoil a painting. Not all painters in the past were competent calligraphers!

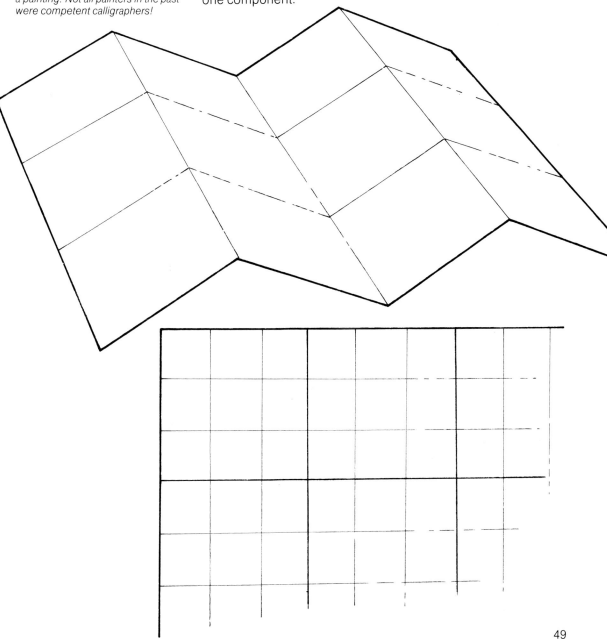

Characters are made up from a series of strokes and the main ones are illustrated.

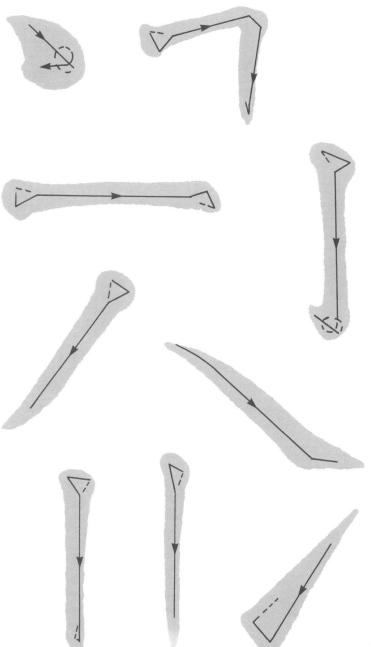

The basic strokes. Follow the direction of the arrows. Dotted lines show very light pressure. As the stroke widens, then increase the pressure.

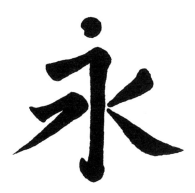

Character for "Eternity" – consists of the basic calligraphy strokes and therefore makes a good example to practise. It contains the character for "water" (flowing endlessly).

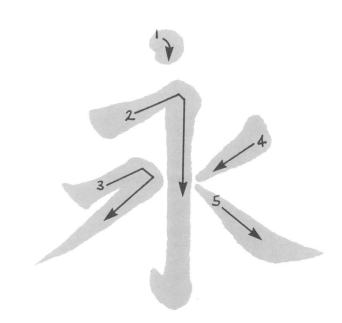

These brushstrokes are contained in the character for eternity, (forever, everlasting, etc.) and this is therefore a good practice piece. There are books available where names may be translated, and bearing in mind that one should be careful when copying, it may be as well to put your name and date rather than be too ambitious!

When adding calligraphy to a painting, it is usual to grind black ink for the characters. However there are times, especially when using the more cursive styles, when very wet or much lighter ink may be more suitable. An artist writing a poem about the rain for instance, might well choose to express the dampness in the calligraphy!

Chinese Calligraphy is a very specialised subject and it is best to study under an expert if you seriously wish to continue with it to any great extent.

In this chapter you are shown how to copy a number of characters, which can be used with your paintings. Each character is shown with the exact sequence of strokes next to it.

Calligraphy by the Author in a cursive style. Lower seal belongs to the artist Zhong Ming, indicating approval. This character means "dream".

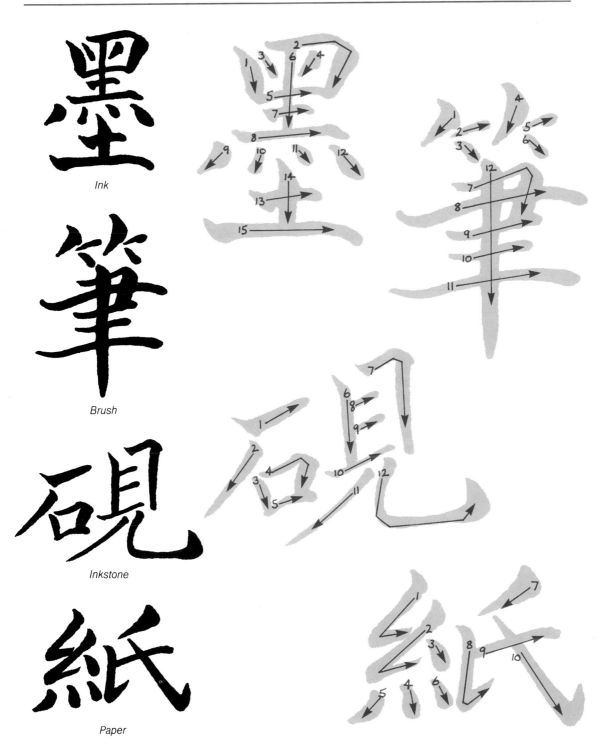

Ink

Brush

Inkstone

Paper

Calligraphy by the Author, again in a cursive style. Lower seal is by Zhong Ming. The meaning of the character is "flower"

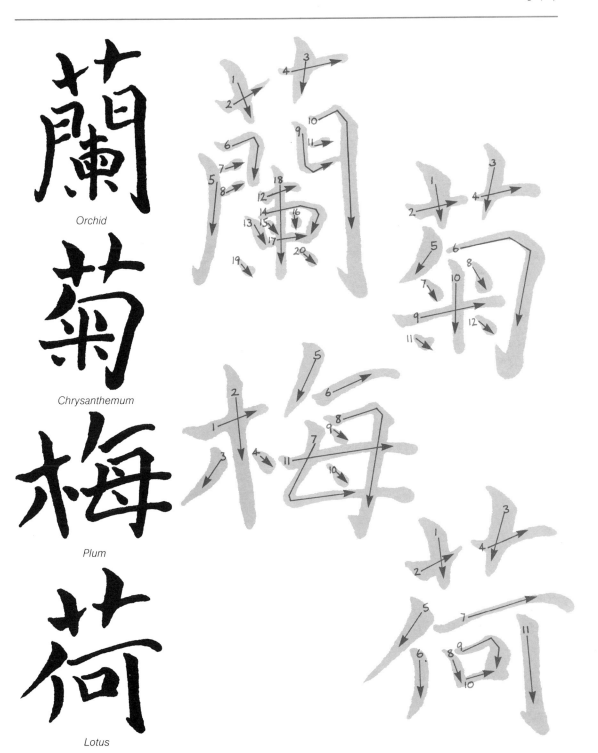

Orchid

Chrysanthemum

Plum

Lotus

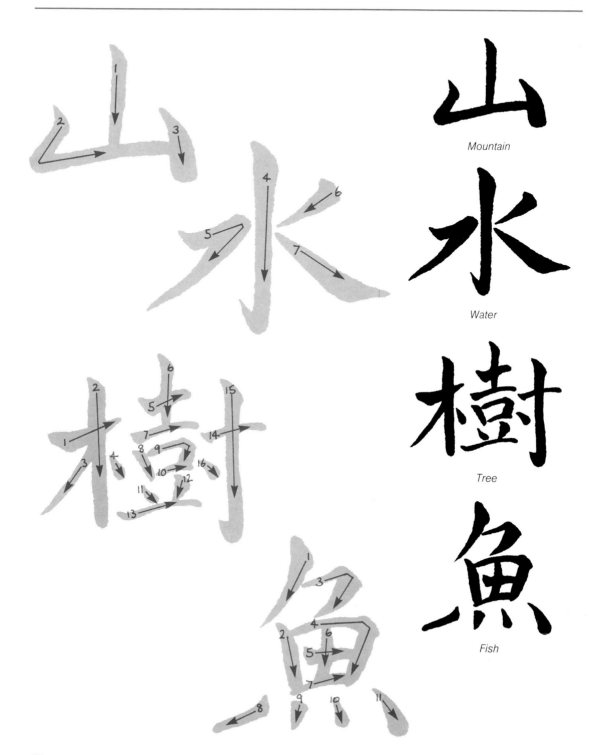

Mountain

Water

Tree

Fish

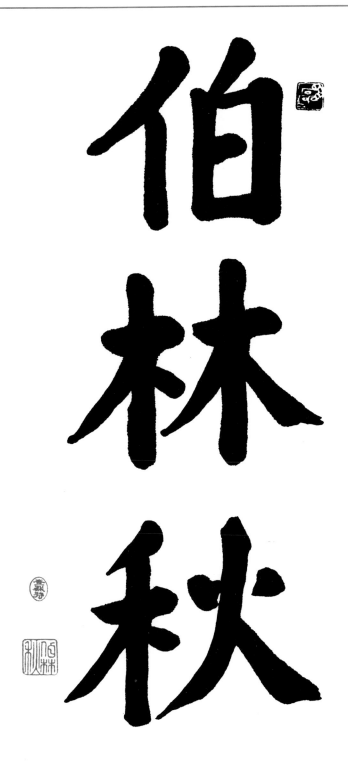

Author's name in a regular script. Calligraphy is by the Chinese artist Qu Lei Lei.

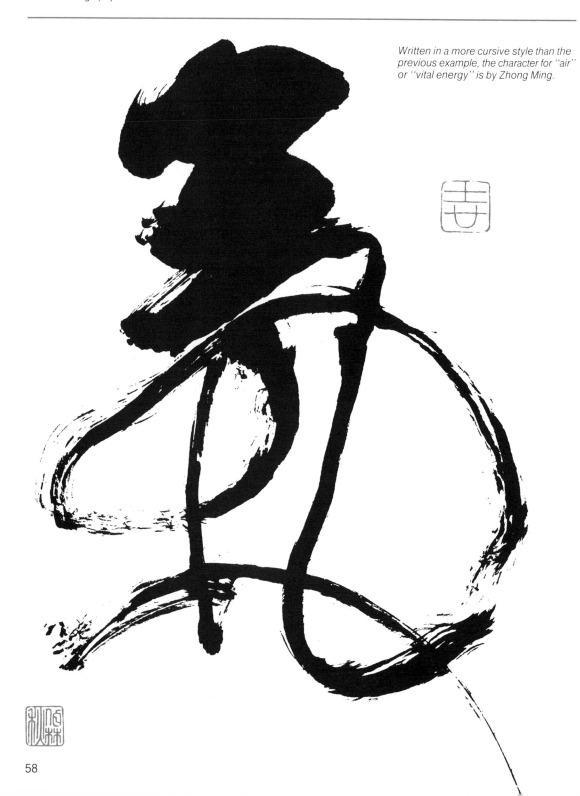

Written in a more cursive style than the previous example, the character for "air" or "vital energy" is by Zhong Ming.

POINTS TO REMEMBER

Below are a few tips to remember, to help you enjoy your painting.

1. Do try to relax and think quietly about what you want to paint while grinding your ink.

2. Make yourself comfortable with enough room to work.

3. Allow for free movement of your arm and have the correct chair height. Many Chinese artists stand when working. If it is a large painting then you may have to move the paper while working.

4. Always work on the smooth side of the paper.

5. Make sure you grind enough ink at a time for your painting.

6. Clean equipment afterwards, especially that containing ink.

7. Dry brushes horizontally or hanging from the loop – do not dry with the point upwards.

8. Create enough space in your painting – "if in doubt, leave it out".

9. Always use the same end of the ink stick.

10. Do not wash your brushes in hot or very warm water – the glue will dissolve.

11. Never put the plastic or bamboo cover back on a brush once it has been soaked – you will ruin your brush.

12. Do not leave the ink stick in contact with the ink stone – both will be ruined.

13. Do not allow your brush to roll or rest on the paper – you will spoil your painting.

14. Protect the paper with your hand while grinding ink or mixing colours to avoid splashing.

Useful Organisations

Chinese Brush Painters Society

A Society set up in January 1988 for anyone interested in Chinese Brush Painting and associated subjects. Suitable for Chinese Brush Painters of any standard.

Presidents – Prof. Jean Long MA and Prof. Joseph Lo BA. Secretary – Carpenters Seven, Grange Road, Alresford, Hants SO24 9HE.

SACU (Society for Anglo Chinese Understanding)

A Society promoting links between the two countries on a cultural level. Activities include tours and painting trips to China.

Secretary – 152 Camden High Street, London NW1 0NE

Far Eastern Painting Society

A Society formed of people who have lived in the East and who meet together in London on a regular basis.

Secretary – 31 Wimpole Street, London WM1 7AE

For residential short courses – a booklet is published twice a year. NIACE, 19B De Montfort Street, Leicester LE1 7GE.

For local classes – enquire at your local Adult Education Authority.

Osmiroid Creative Leisure Series

Each title in the Osmiroid Creative Leisure series has been written in a lively "to the point" style, with very practical advice to ensure that exciting creative results are quickly achievable.

Colour Calligraphy explains colour theory and shows some of the many ways that imaginative colour calligraphy can be created.

Pen and Ink Drawing leads the reader through many subjects and styles and includes enough "tricks of the trade" to ensure that everyone can create something.